DANCING RAINBOWS

A Pueblo Boy's Story

Text and photographs by

Evelyn Clarke Mott

COBBLEHILL BOOKS / Dutton · New York

For the Garcia family with many thanks for their warm friendship.

E C M

ACKNOWLEDGMENTS

The author would like to thank the following people for helping
to make this book possible:
The gracious people of San Juan Pueblo, my fellow writers at
Bucks County Authors of Books for Children and Lakeside Writers for
Young People, Mary Barrett, Joe Ann Daly, Wayne Edmonds, Gary and
Mari Gentel, Sue Kassirer, Kate Klimo, Susan Korman, Rosanne Lauer,
Douglas Mott, Larry Phillips, and all my friends at Yardley Photo-Video.

Contributions or requests for information about
the Tewa Dancers of the North may be made to:

Tewa Dancers of the North
Andrew Garcia, Coordinator
P. O. Box 1055
San Juan Pueblo, New Mexico 87566
(505) 753-2087

Copyright © 1996 by Evelyn Clarke Mott
Library of Congress Cataloging-in-Publication Data
Mott, Evelyn Clarke.
Dancing rainbows / text and photographs by Evelyn Clarke Mott.
p. cm.
Summary: A young Tewa Indian boy and his grandfather prepare to take
part in their tribe's feast which will include the special Tewa dance.
ISBN 0-525-65216-7
1. Tewa Indians—Juvenile literature. 2. San Juan Pueblo (N.M.)—
Juvenile literature. 3. Tewa dance—Juvenile literature.
[1. Tewa dance. 2. Dancing. 3. Indian dance—North America.]
I. Title.
E99.T35M67 1996 978.9'52—dc20 95-32221 CIP AC r95
Published in the United States by Cobblehill Books,
an affiliate of Dutton Children's Books,
a division of Penguin Books USA Inc.,
375 Hudson Street, New York, New York 10014
Designed by Kathleen Westray
Printed in Hong Kong
First Edition 10 9 8 7 6 5 4 3 2 1

SOME of my best and most memorable moments as a child were on Feast Day—baking the bread, walking through the crowd, hearing the beat of the drum, and dancing!

Shadeh is the Tewa word for dance. It means "to wake up." By dancing, one awakens to a heightened sense of awareness to the dance and its meaning.

For Tewas, dance is a meaningful part of our lives. Our dances have deep religious meaning. When we dance, we always do our best. We never dance for ourselves. We dance for everything and everybody.

The beautiful culture my ancestors passed on could turn into a shadow. A lot of my life is devoted to preventing that.

My efforts began in 1974 when I formed the Tewa Dancers of the North. The group has given many of our young people a chance to travel and share our dances throughout the world. We were honored to be the Native American dance group chosen to perform at the 1992 presidential inauguration.

Our young dancers help preserve the important traditions for the future. They will someday teach others how to dance. They will be the role models of the future.

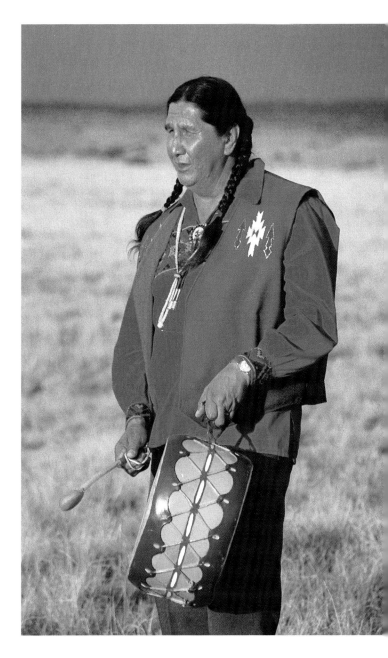

Our ancestors have given us beautiful songs and colorful dances. I am honored to share my tribe's Feast Day and some of our dances with you. *Shadeh!*

ANDY GARCIA
NaNa Tśą́ą̨ (White Aspen)

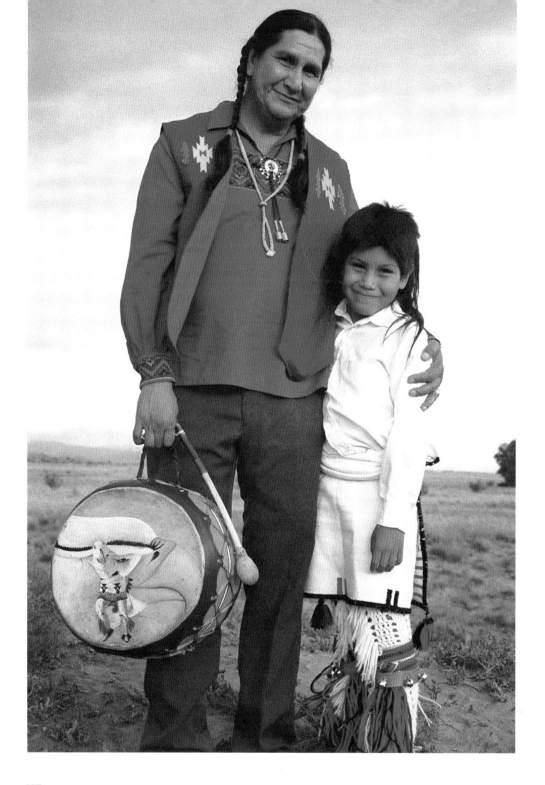

It is the day before Feast Day. Curt and his grandpa, Andy, are excited. Every year, on June 24, their pueblo has a big party with food, fun, and dance.

Pueblo is a Spanish word for town. Curt and Andy Garcia are Pueblo Indians. Their tribe is called Tewa. They live in San Juan Pueblo, New Mexico.

San Juan Pueblo is named after Saint John. On Feast Day, native dances honor the pueblo's patron saint and celebrate the power of the summer sun.

Curt's ancestors were farmers. They grew corn, beans, and squash.

Now, most Tewas work at businesses outside the pueblo, but some still farm.

"We must always take care of our land," Andy tells Curt. "We must respect Mother Earth."

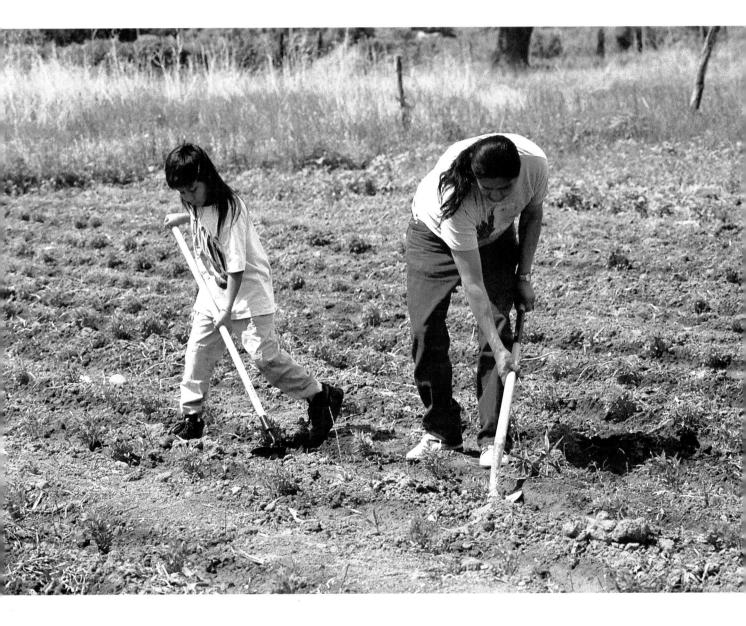

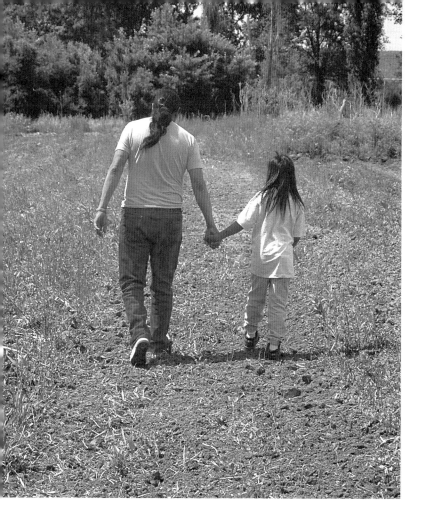

Curt spends a lot of time with his grandpa. He learns so much. They share many laughs.

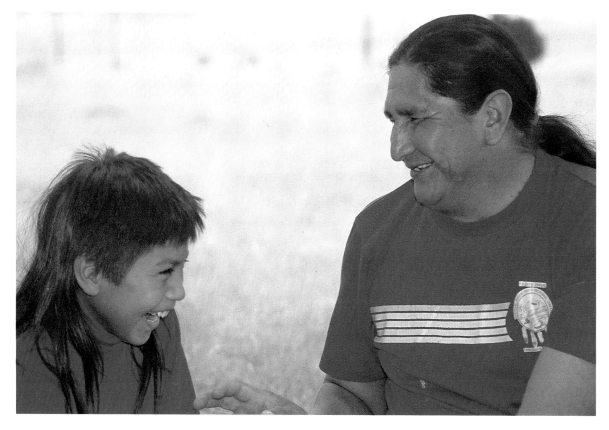

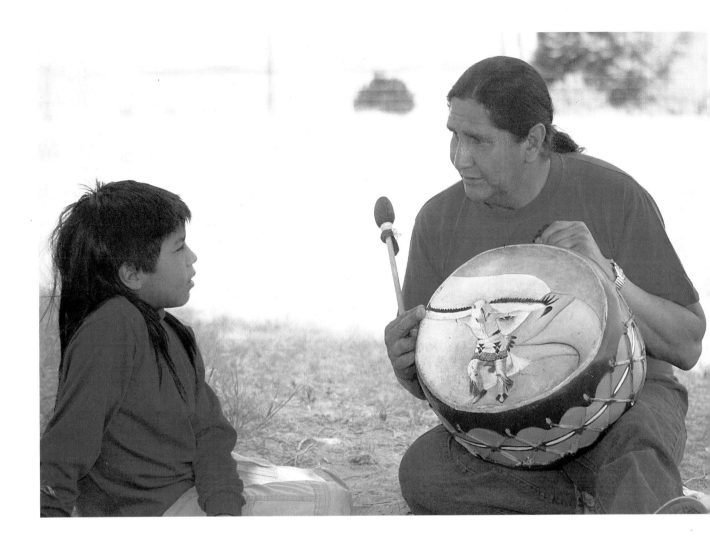

Andy is an elder in his tribe. That means he is very respected. He is well known among his people as a great dancer.

"Dance with all your heart!" Andy says.

All Tewa dances are prayers. The Tewa people dance to cure the sick, to give thanks, to bring the tribe together, to pray for good crops, and to have fun!

Because the Tewas' land is very dry, every dance is also a prayer for rain.

"Let's hurry, Grandpa!" Curt says. "It's time for the Buffalo Dance!"

Curt and Andy rush to the plaza.

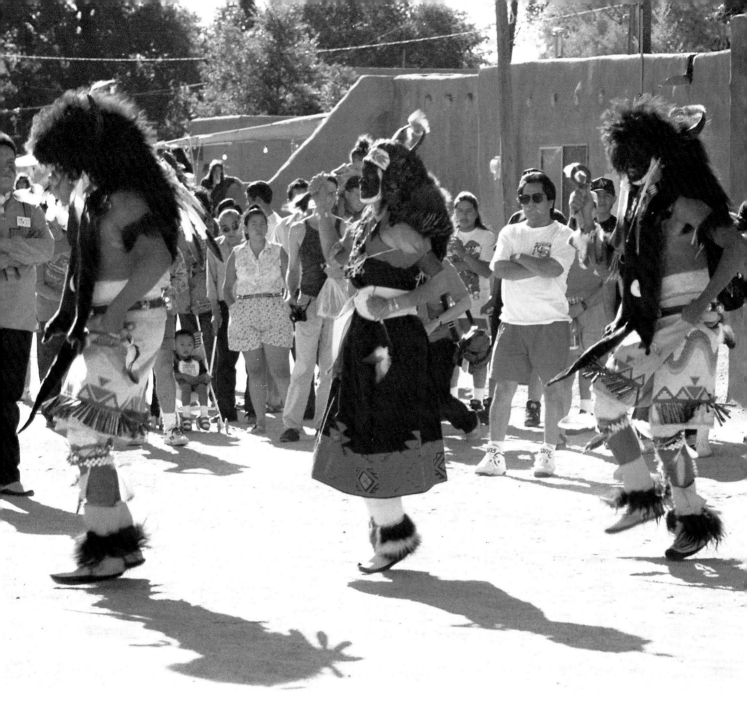

The plaza is the center of town. It is where the tribe meets. Three people dance in buffalo costume.

Tewas believe that people and animals once spoke the same language. This ended when people started to lose respect for the animals.

Tewas show their respect for all animals with the Buffalo Dance. This dance blesses tomorrow's Feast Day. It is said to give the tribe strength and power.

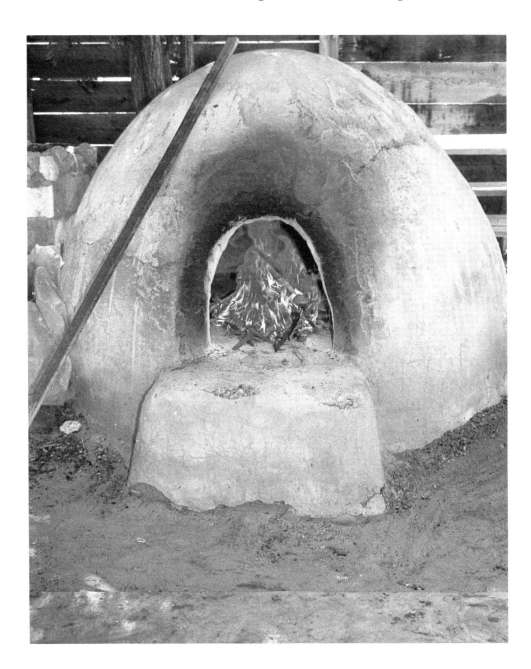

The smell of baking bread welcomes Curt and Andy home from the dance. For Feast Day, Curt's mom and relatives all help bake over seventy loaves of bread in the horno, an oven for baking bread, cakes, and cookies. It is shaped like a beehive.

The horno sits outside the house. Curt's mom makes a fire to heat up the oven. Then, she cleans out the ashes and puts in the dough.

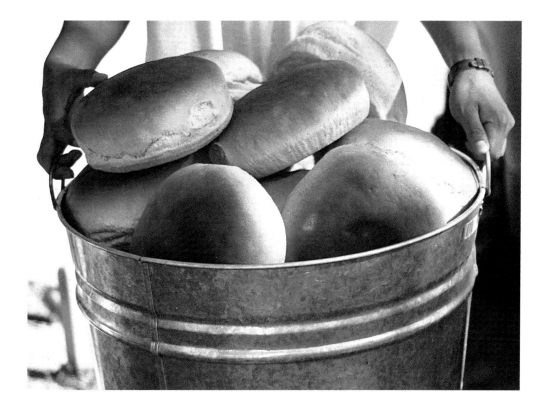

The dough bakes in the warm oven. Curt's mom pulls out the hot bread.

Dogs wait near the horno eager for a taste!

The Garcia house smells of stew, bread, cakes, and candy. Everyone looks foward to tomorrow's feast!

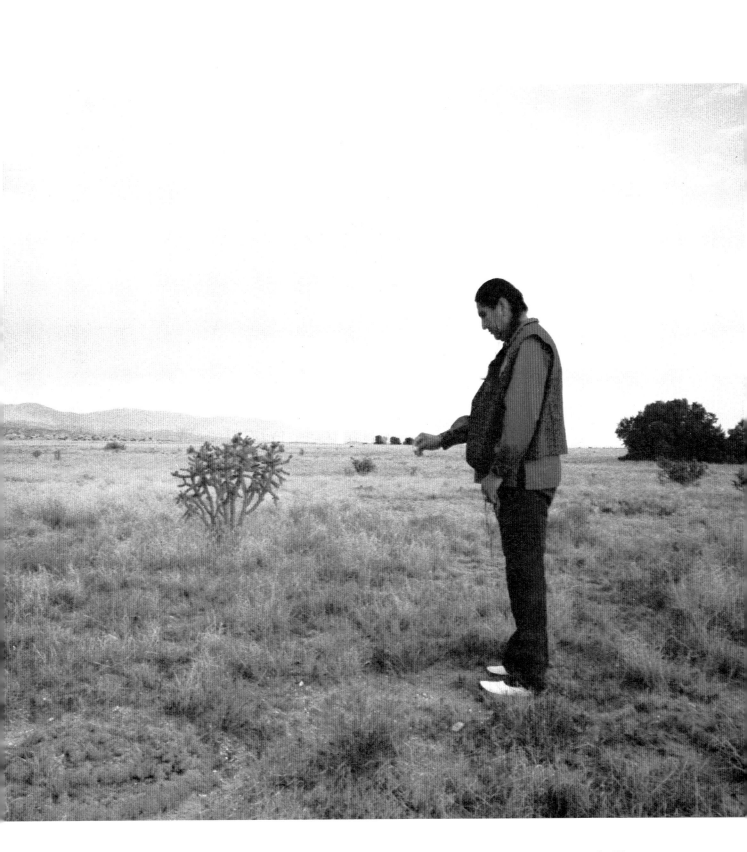

Andy wakes up early on Feast Day. He prays in the hills.
He asks for a good mind, a good heart, and a good life. He
sprinkles some cornmeal as a gift to the earth.

Today looks bright and sunny. But even if it rains, everyone will dance. Tewas believe rain is good luck. They say their ancestors come back as raindrops to help them live.

Rainbows are also good luck. They join Mother Earth with Father Sky.

Soon, all the Garcias are
awake. Everyone hurries
to get ready.

Andy's wife, Verna,
sprinkles salt on his head.
She says it keeps away
bad spirits.

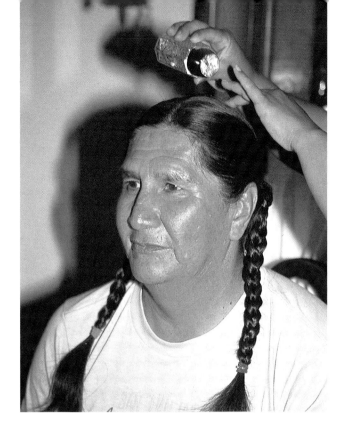

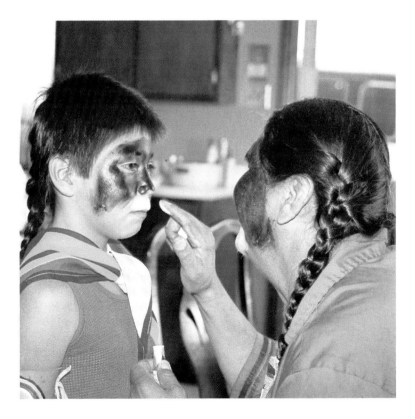

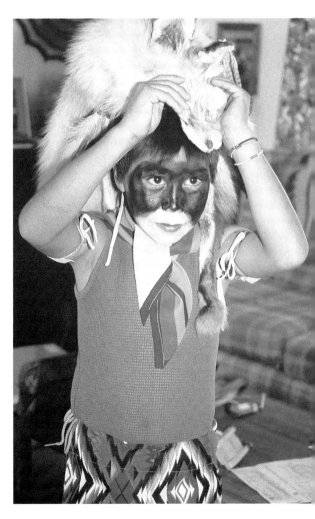

Andy helps Curt put on face paint.
Curt pulls a fox skin over his head.
He puts on his Comanche costume.

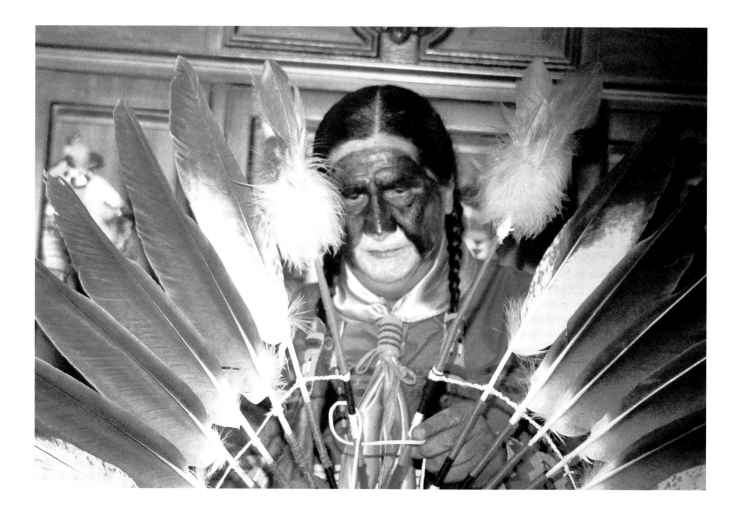

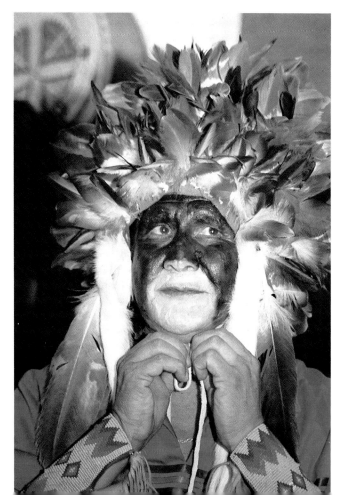

Andy fixes his bustle. He ties on his headdress.

With everyone ready, the Garcias head toward the plaza.

BOOM! BOOM! BOOM! The drummers move through the crowd.

Indians say drums have great power. They believe a drum sounds the heartbeat of Mother Earth.

Drummers paint their hands white to give their drumbeats more power.

The drummers sing in Tewa. They sing of many things. Plants. Animals. Clouds. Rainbows. They try to sing like birds. Bird songs are so beautiful.

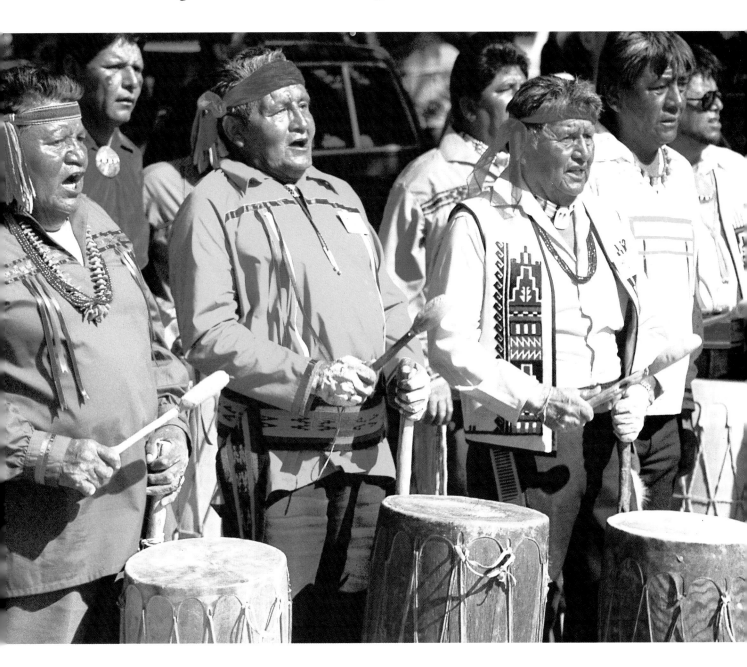

The Comanche Dance starts. Over a hundred Tewas, from three to eighty years old, move their feet to the beat of the drum.

In this dance, they are imitating the Comanche warriors, acting as they would in battle. The dancers pray for the Tewa tribe and give thanks for their blessings.

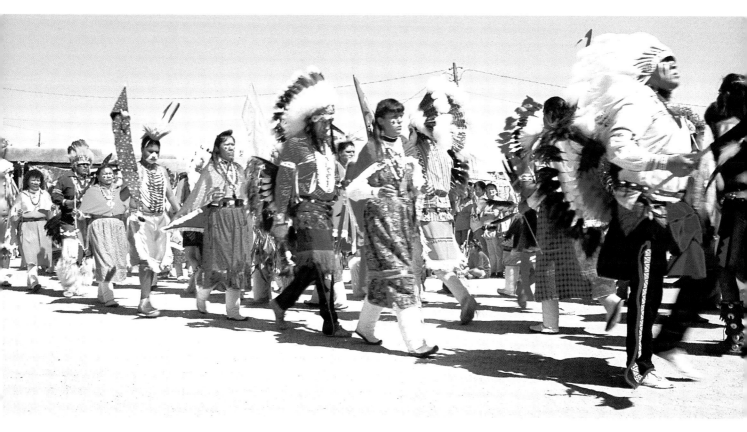

Colors twirl
and swirl.

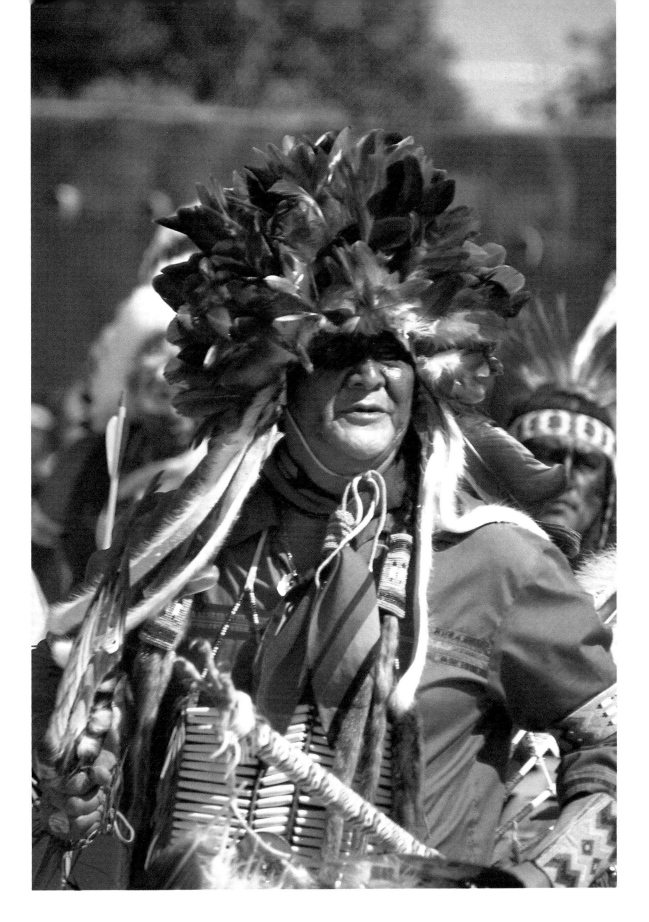

Andy dances proudly.

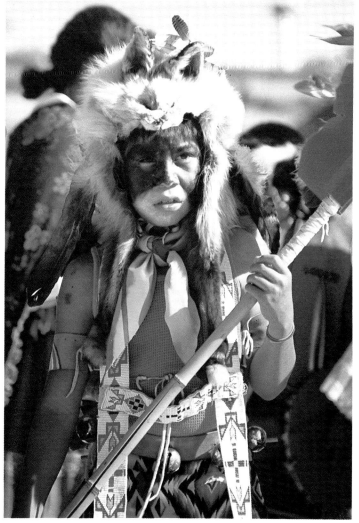

Tewas dance their thanks to the Great Spirit. They pray for their tribe's happiness. They pray for Mother Earth.

Jingle . . . Jingle . . . Jingle. Bells ring as Curt moves his feet. He thinks of his grandpa's words, "A Tewa never dances for himself. He dances for all things and people."

Curt sends out prayers to the crowd. He wishes them a good life and a safe trip home.

In 1923, the United States made Indian worship illegal. Tewas could no longer visit their kivas— a place of worship.

Indians could not dance. All Indian dances were seen as war dances. It wasn't until 1935 that Indians could dance again.

Tewas forgive the United States government. At Feast Day, the flag flies proudly. Many Tewas have fought for their country.

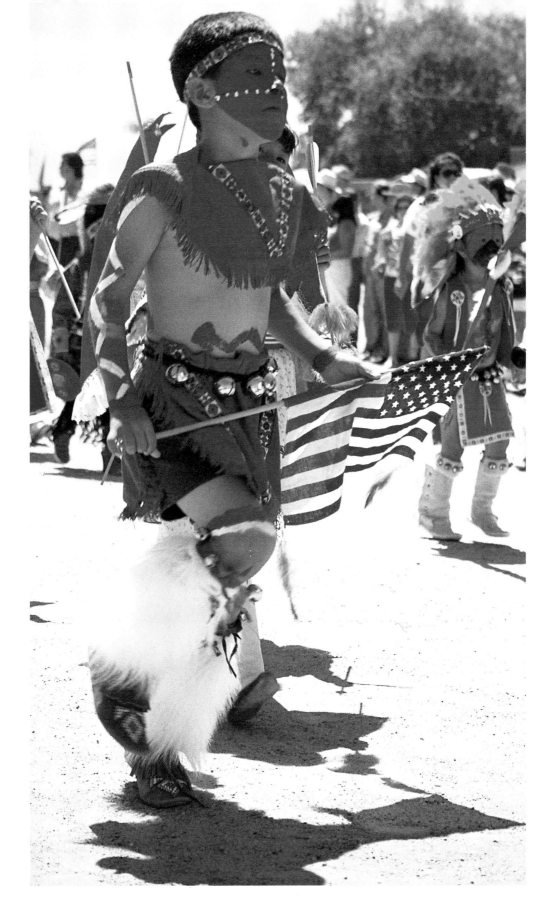

Some dancers show pride for their country.

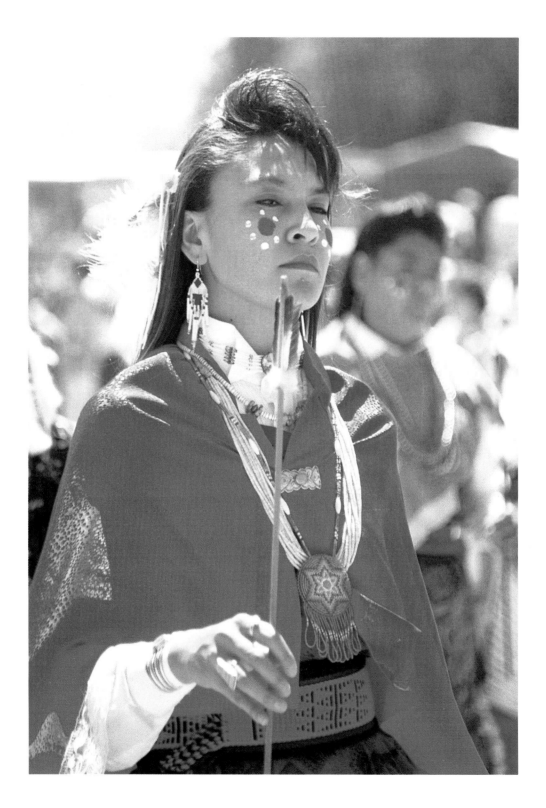

Tewa women dance with grace. To celebrate the power of the sun, they paint the red sun on their cheeks.

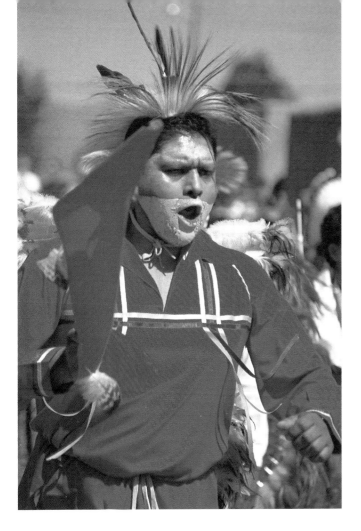

The men yelp loudly for the Comanche Dance. They wear fancy costumes.

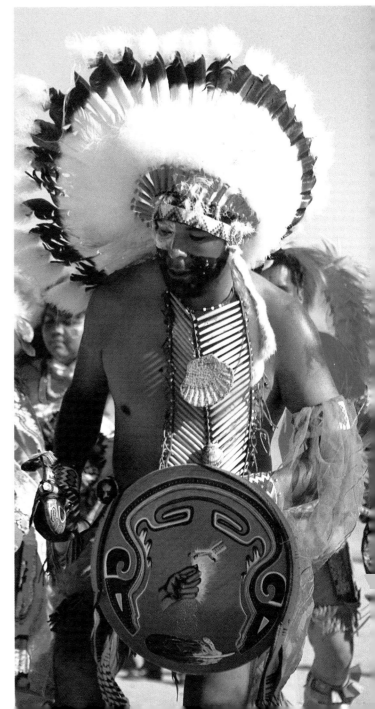

Tewa children dance with honor. They learn to dance as soon as they walk. That is why they are good, strong dancers.

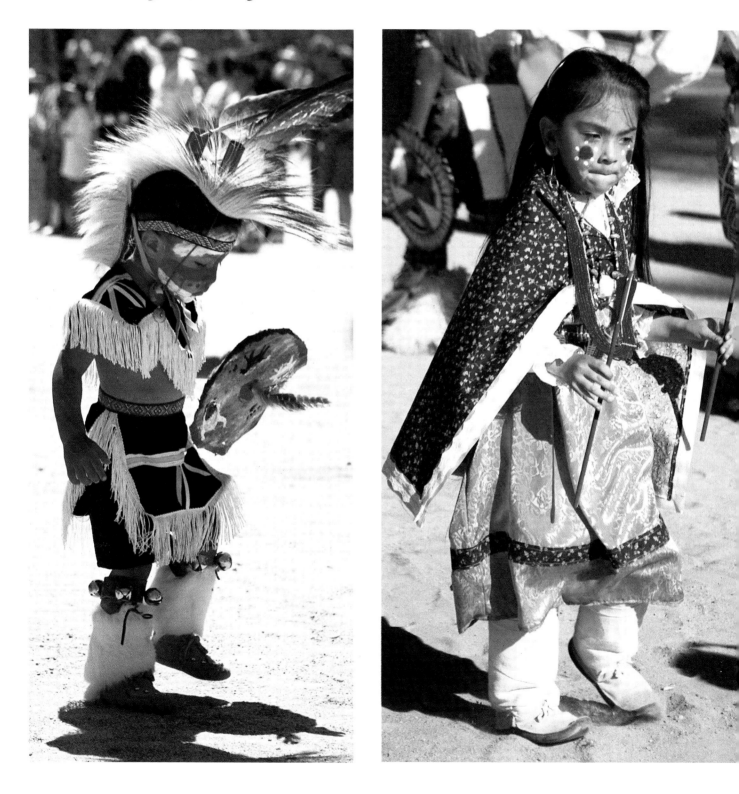

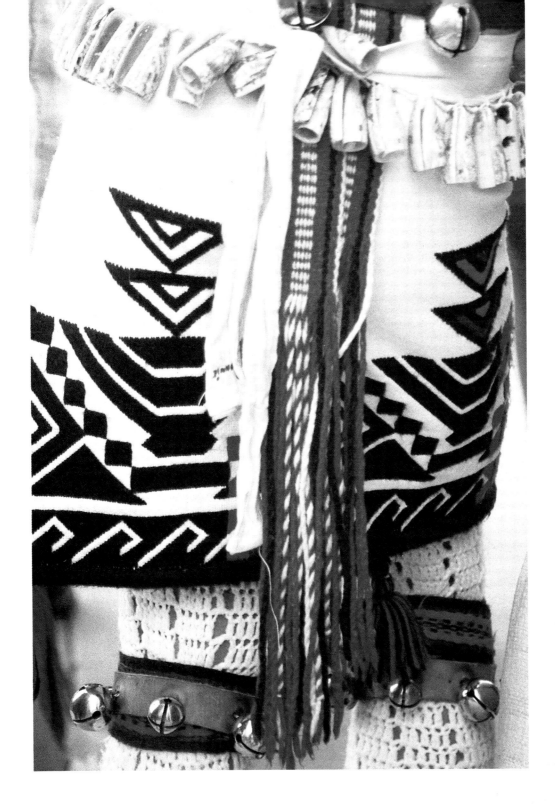

Costumes have many meanings.
Shells sound like waves hitting the shore.
Tassels look like raindrops.
Bells sound like falling rain.
Embroidered designs look like clouds.

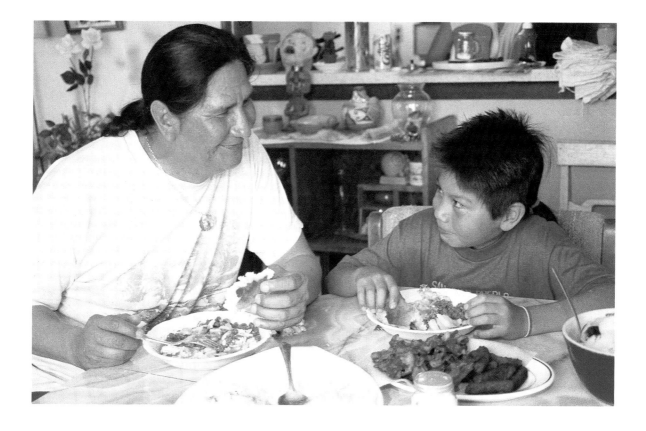

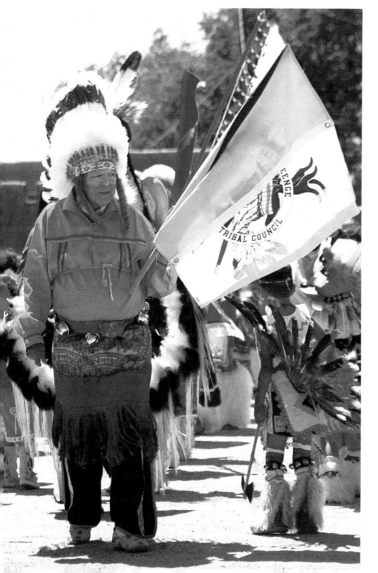

The dancers go home for the feast. Tewa homes fill with friends and family. There is so much to eat.

Andy says he doesn't hear any talking. Only chewing!

After the feast, everyone meets at the plaza. They dance again in the hot sun.

As the sun sets, the dancers go home.

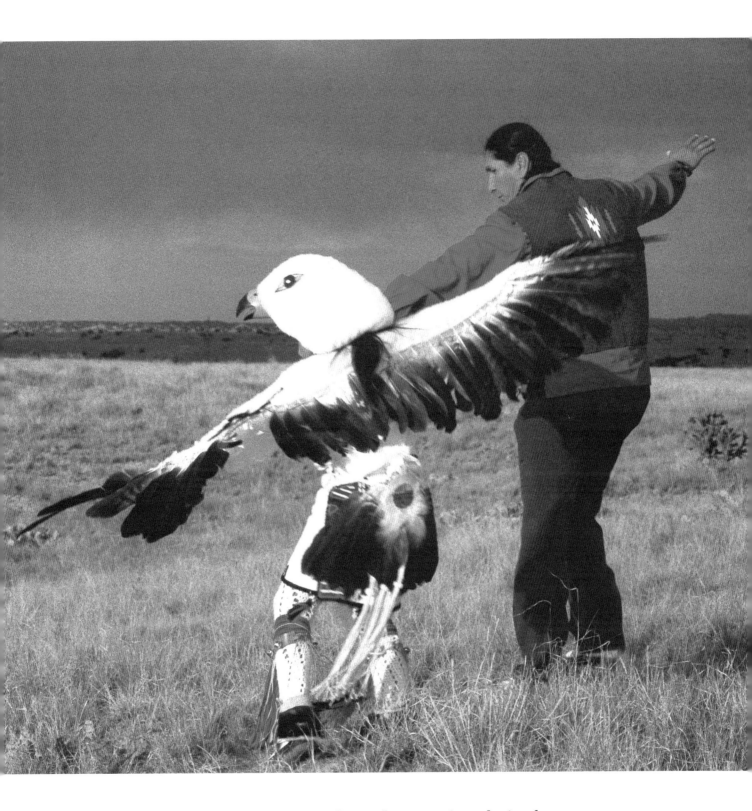

Sometimes, Curt and Andy practice their dances.
Andy teaches Curt. Curt respects his grandpa because
he is very wise. Curt tries to be like his grandpa.

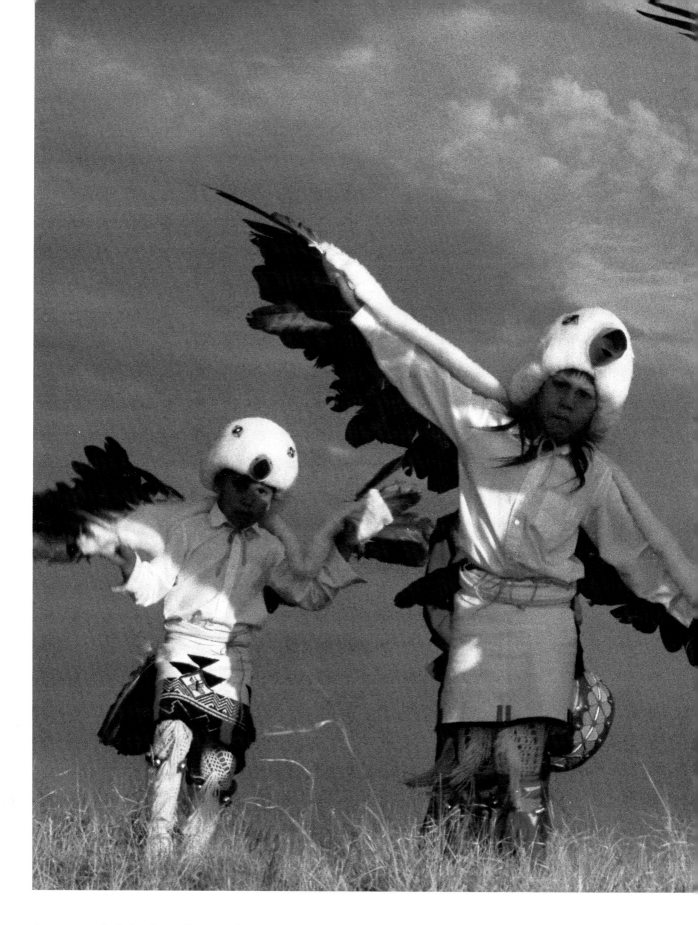

Curt and his brothers do the Eagle Dance. They swoop, soar, land,

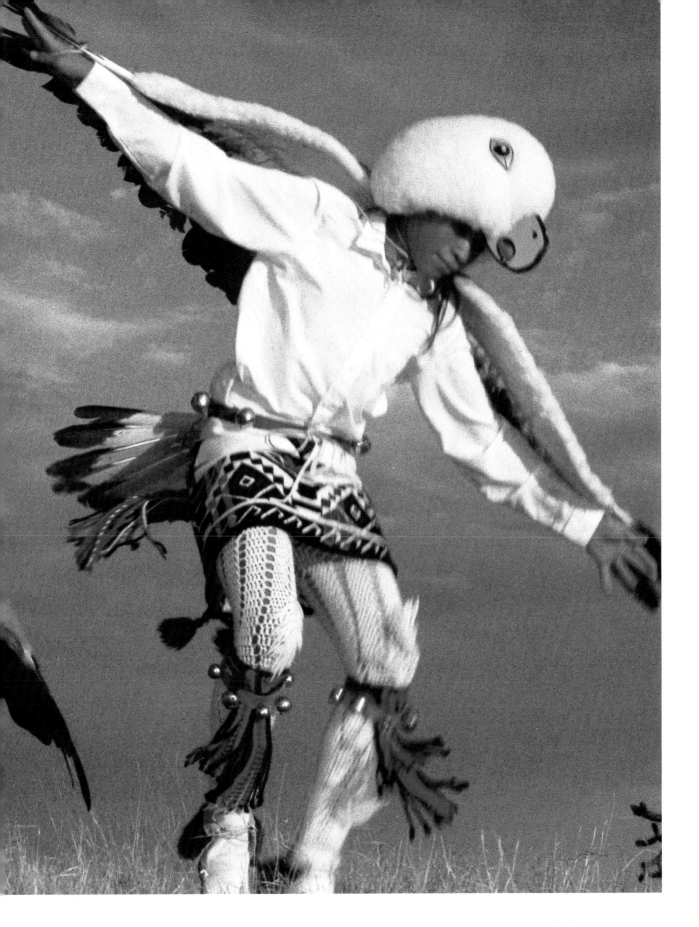

circle, and rest. They keep perfect time to the beat of the drum.

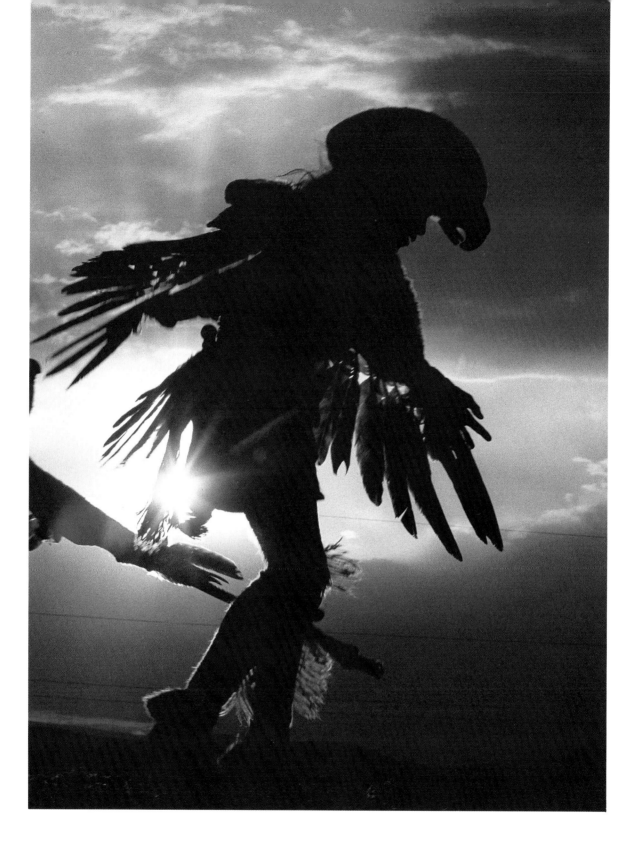

The eagle flies higher than any other bird. Tewas believe that eagles are messengers. They say that eagles bring prayers to the clouds and messages back to the earth.

Tewas dance to give thanks to the great bird.

Andy started a dance group for Curt and other young Tewa dancers.

The group often dances outside the pueblo. Fairs. Schools. Hospitals. Powwows.

The day after Feast Day, Curt dances at a city fair. He says it doesn't matter where he dances. His prayers still reach the clouds.

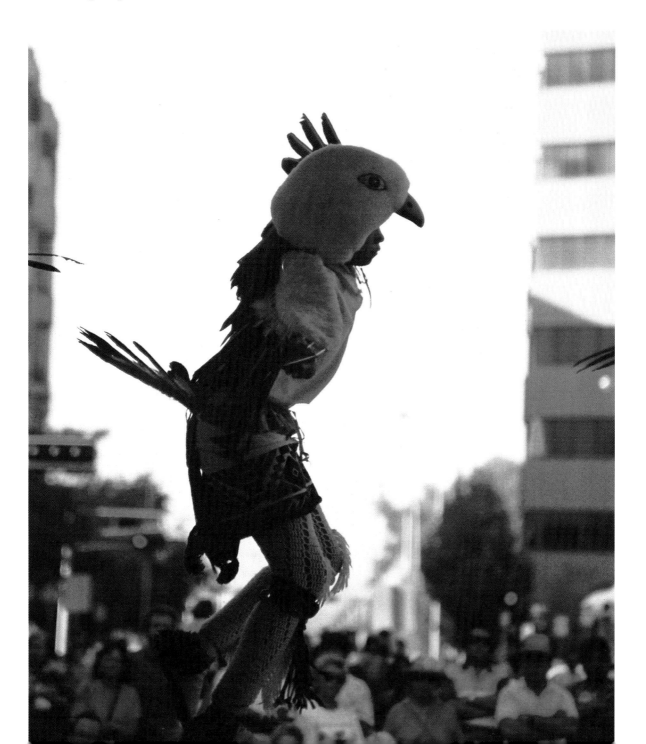

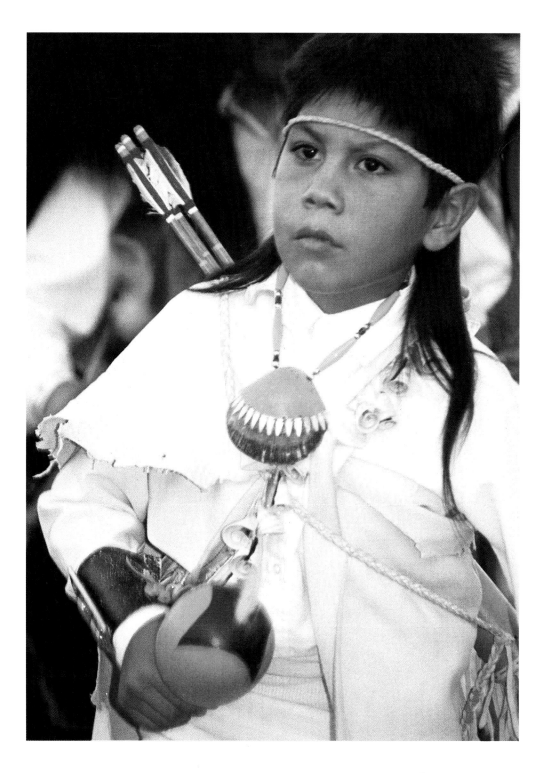

Curt is proud to be Tewa. His ancestors have given him so much. Beautiful songs. Colorful dances.

Curt is happy to follow his grandpa's footsteps. Dancing for rain. And rainbows.